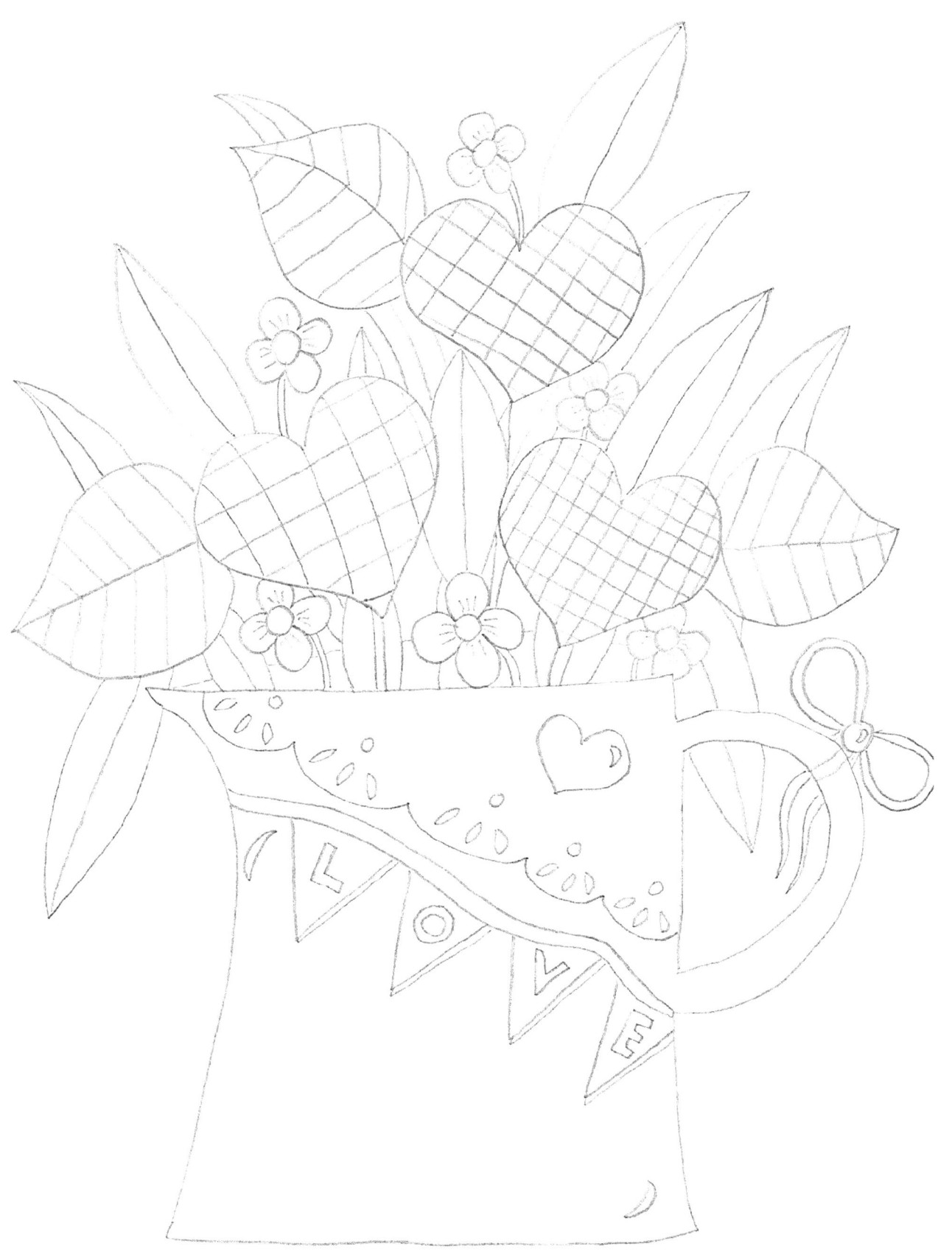

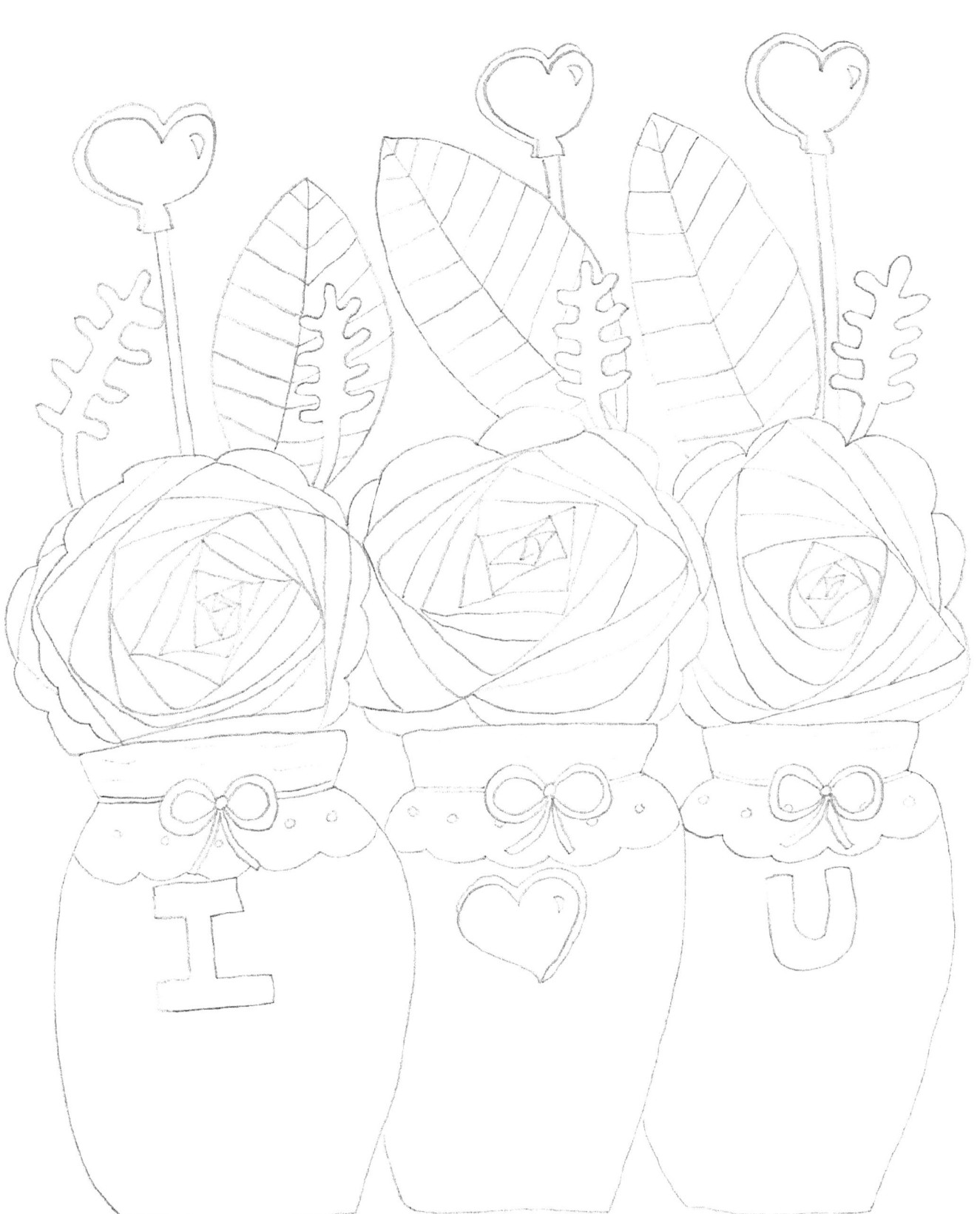

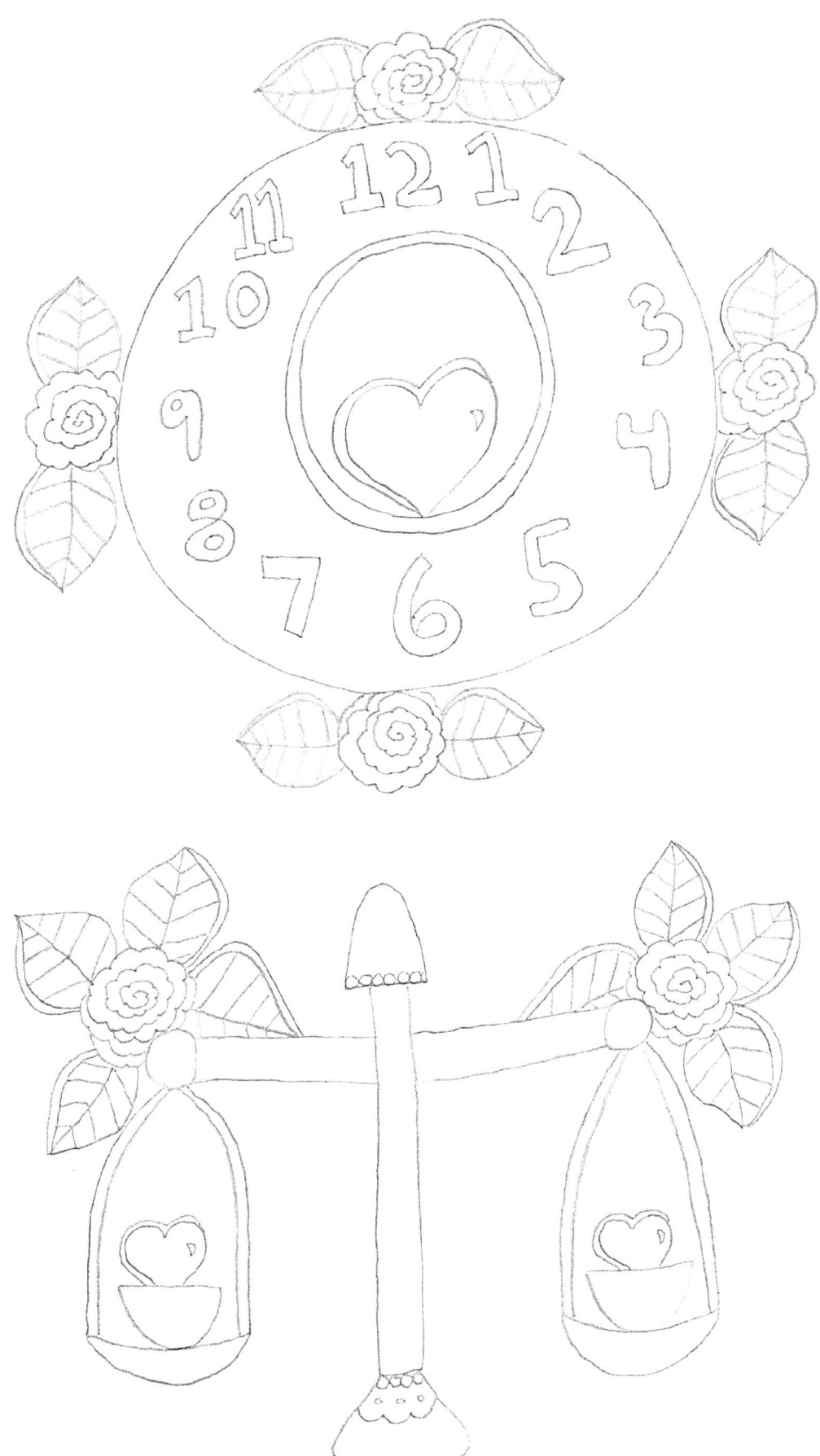

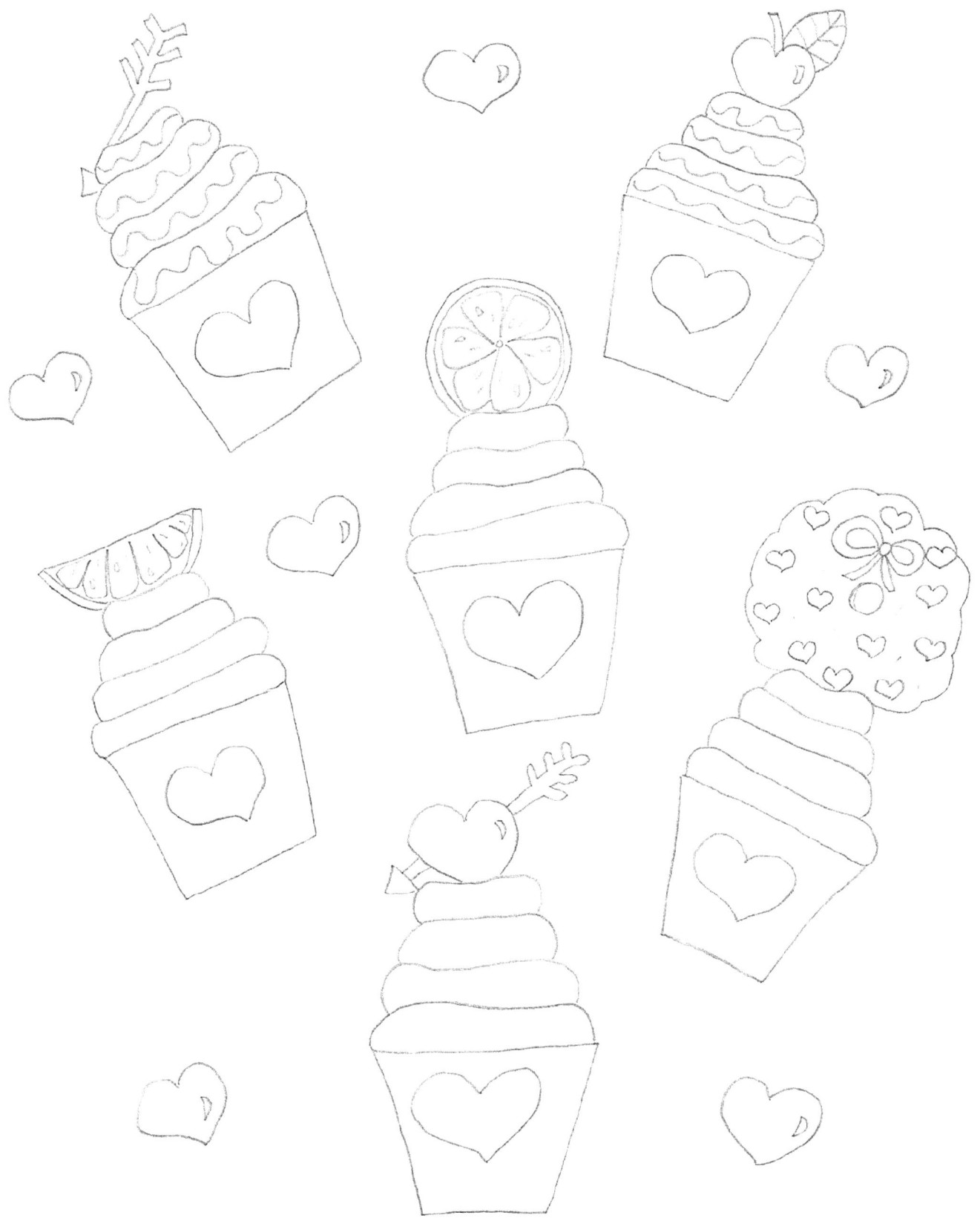

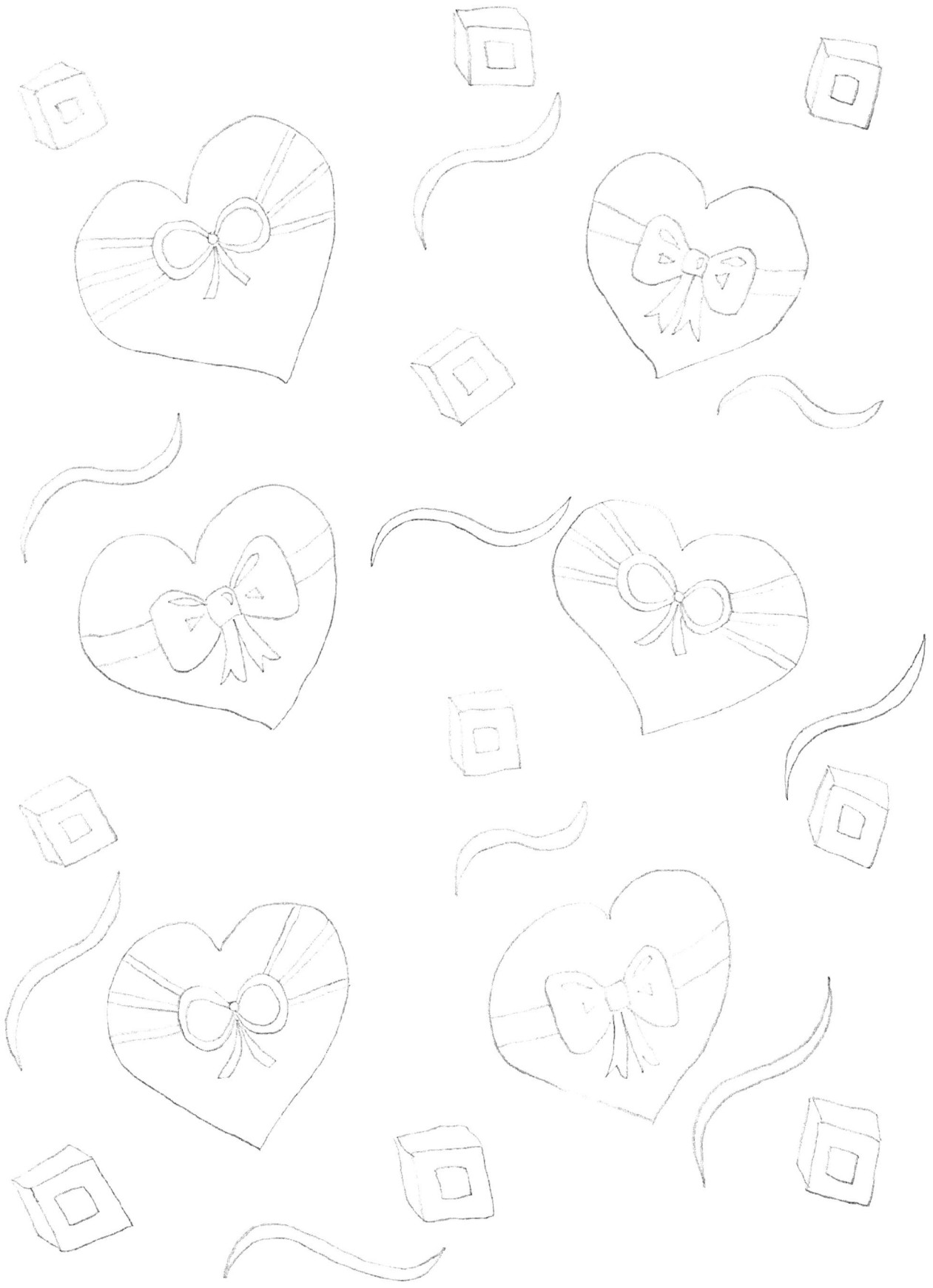

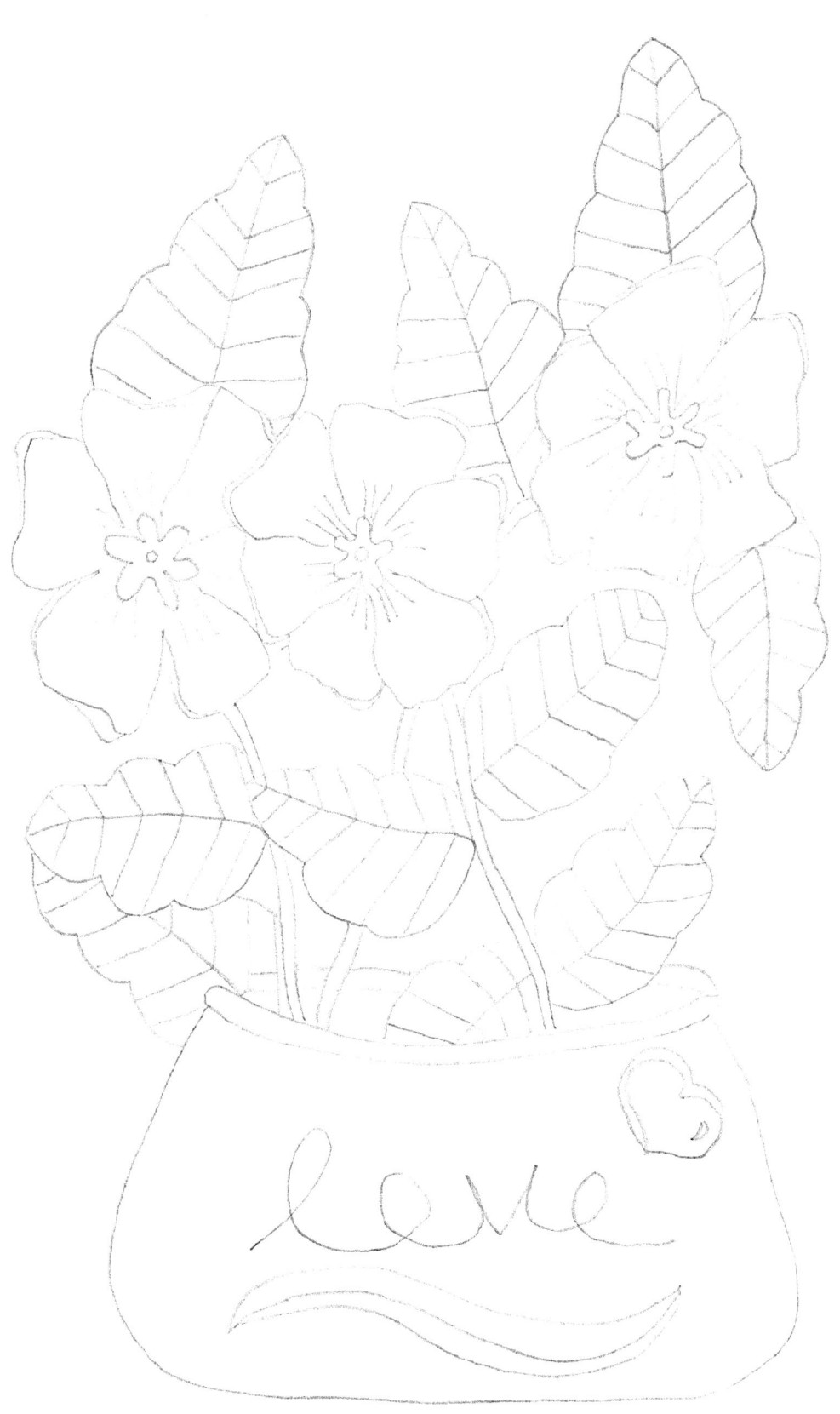

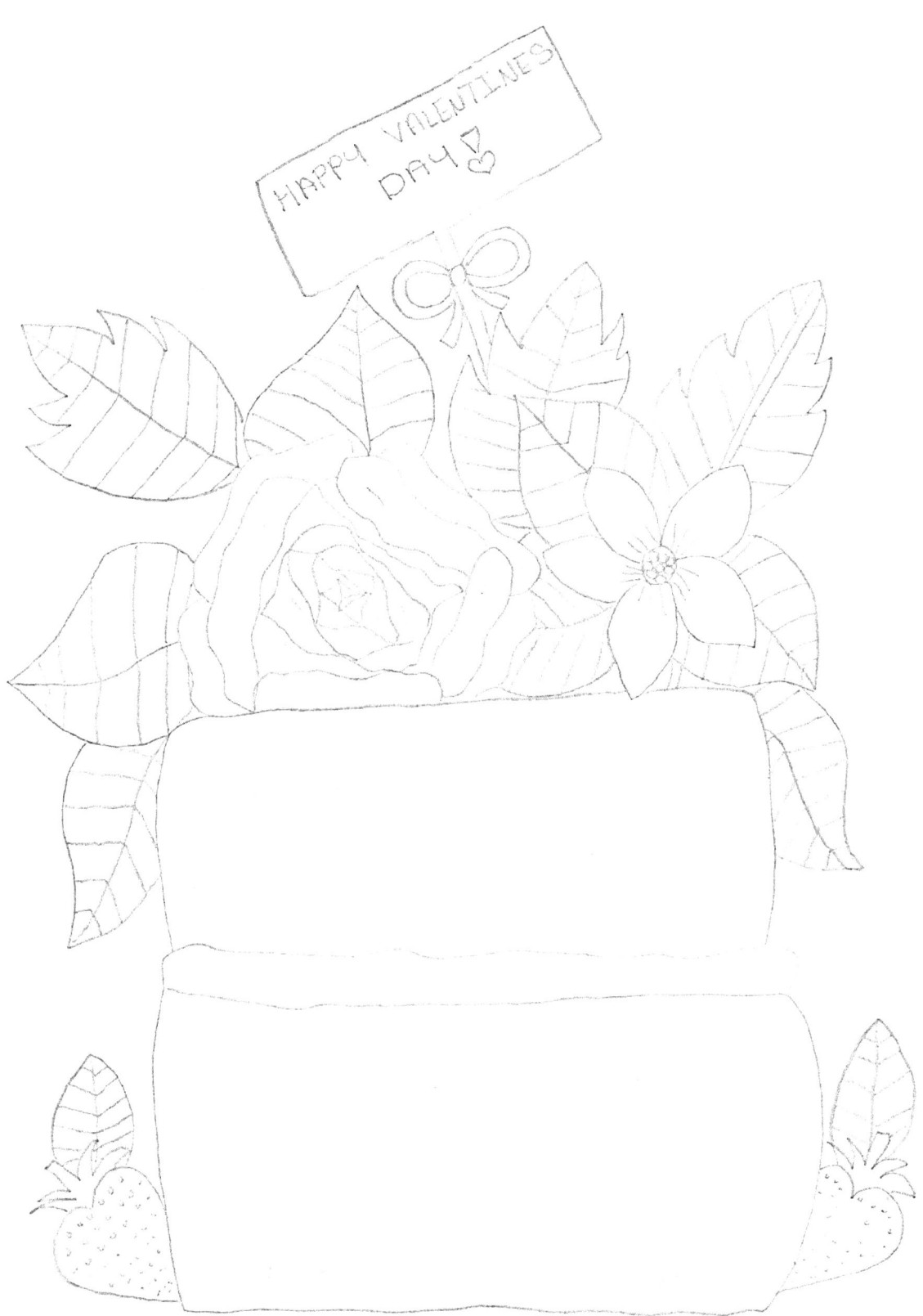

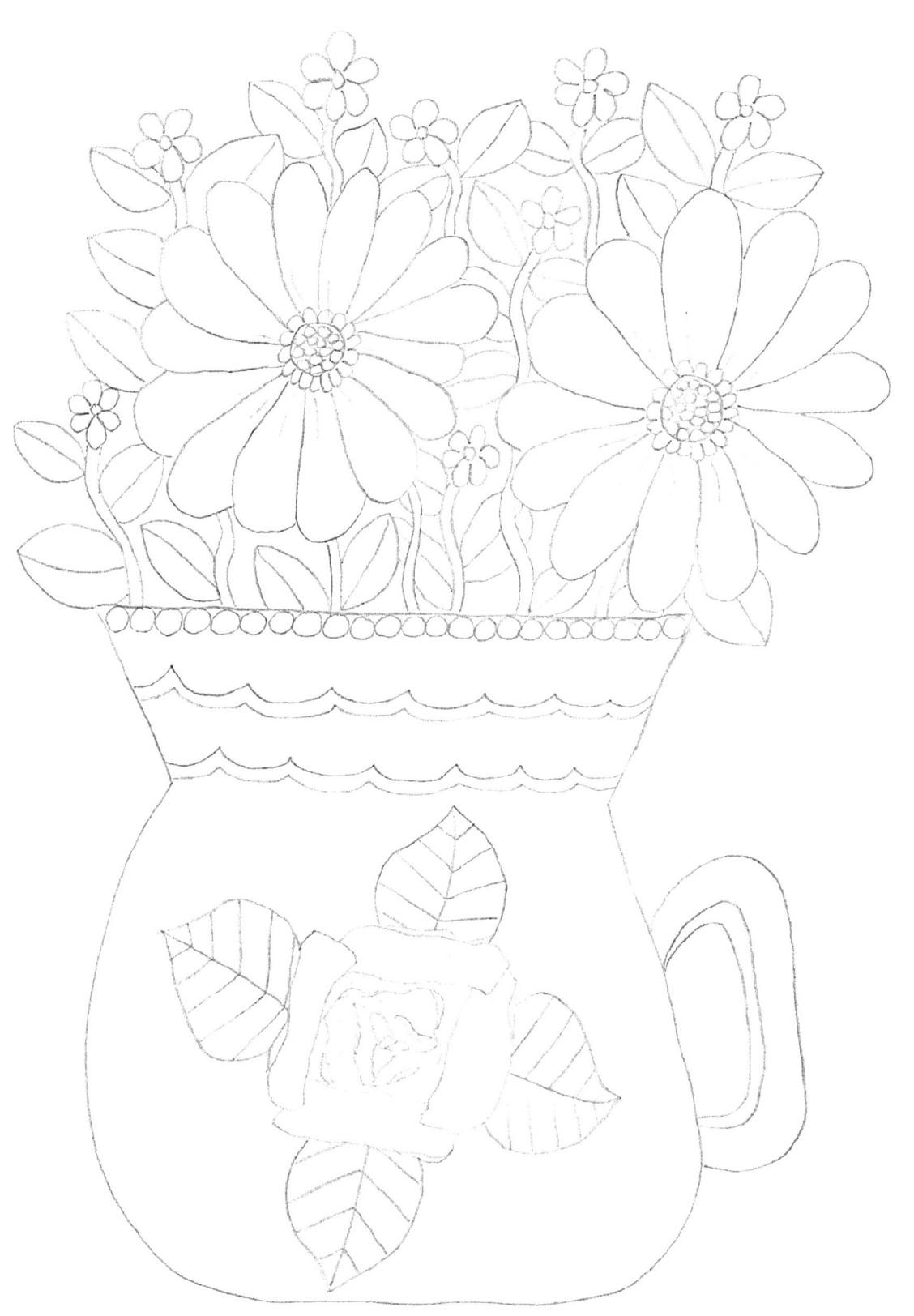

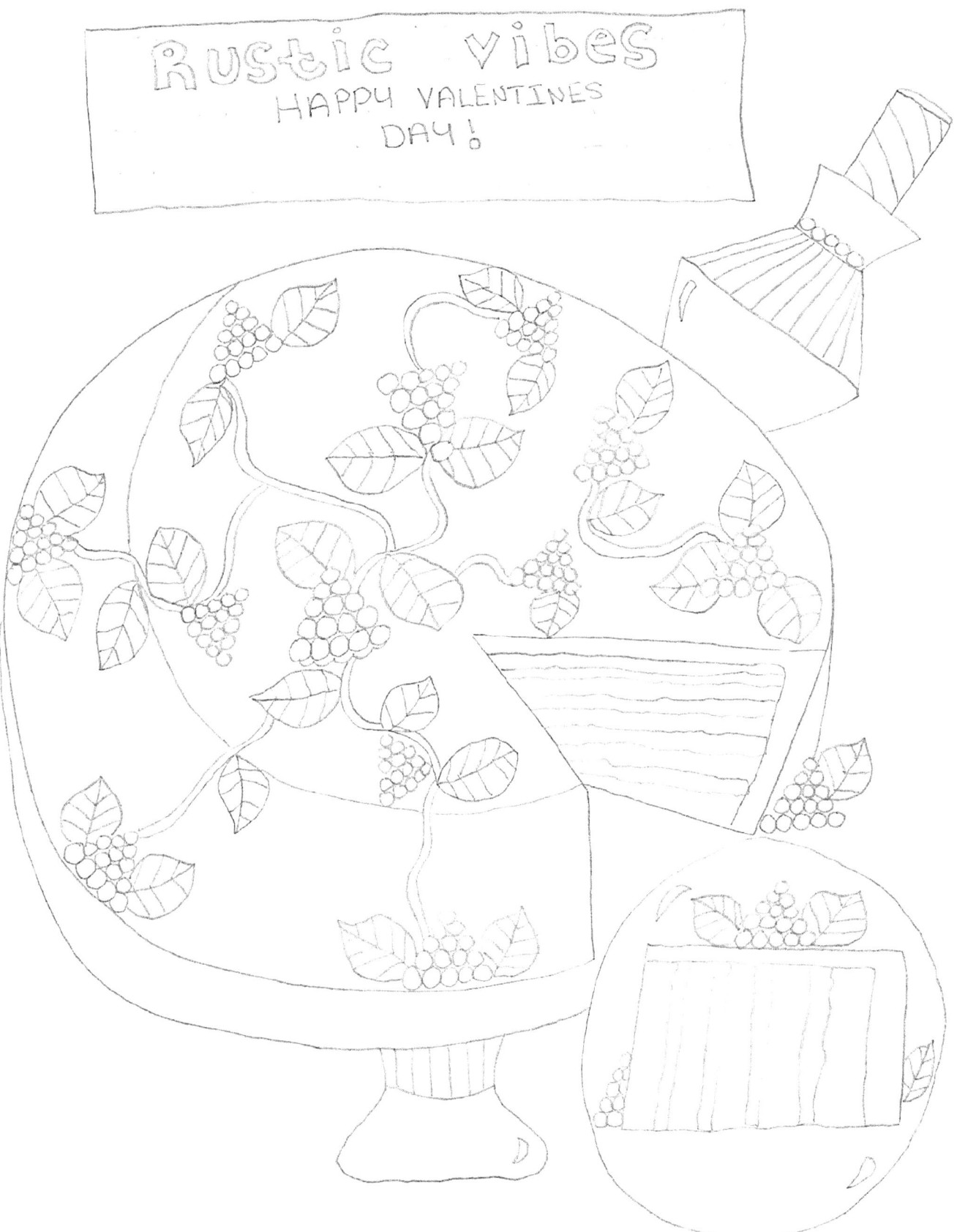

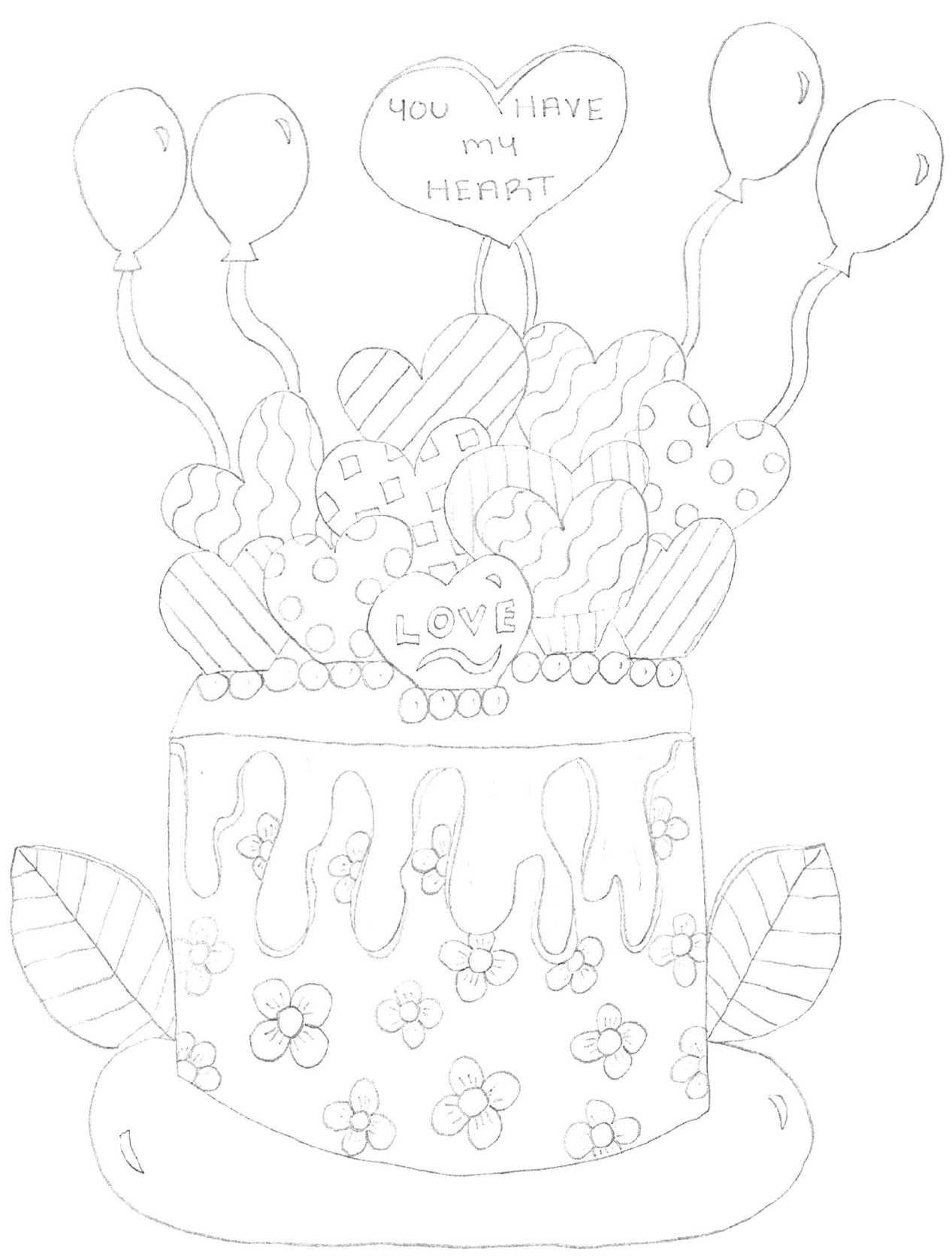

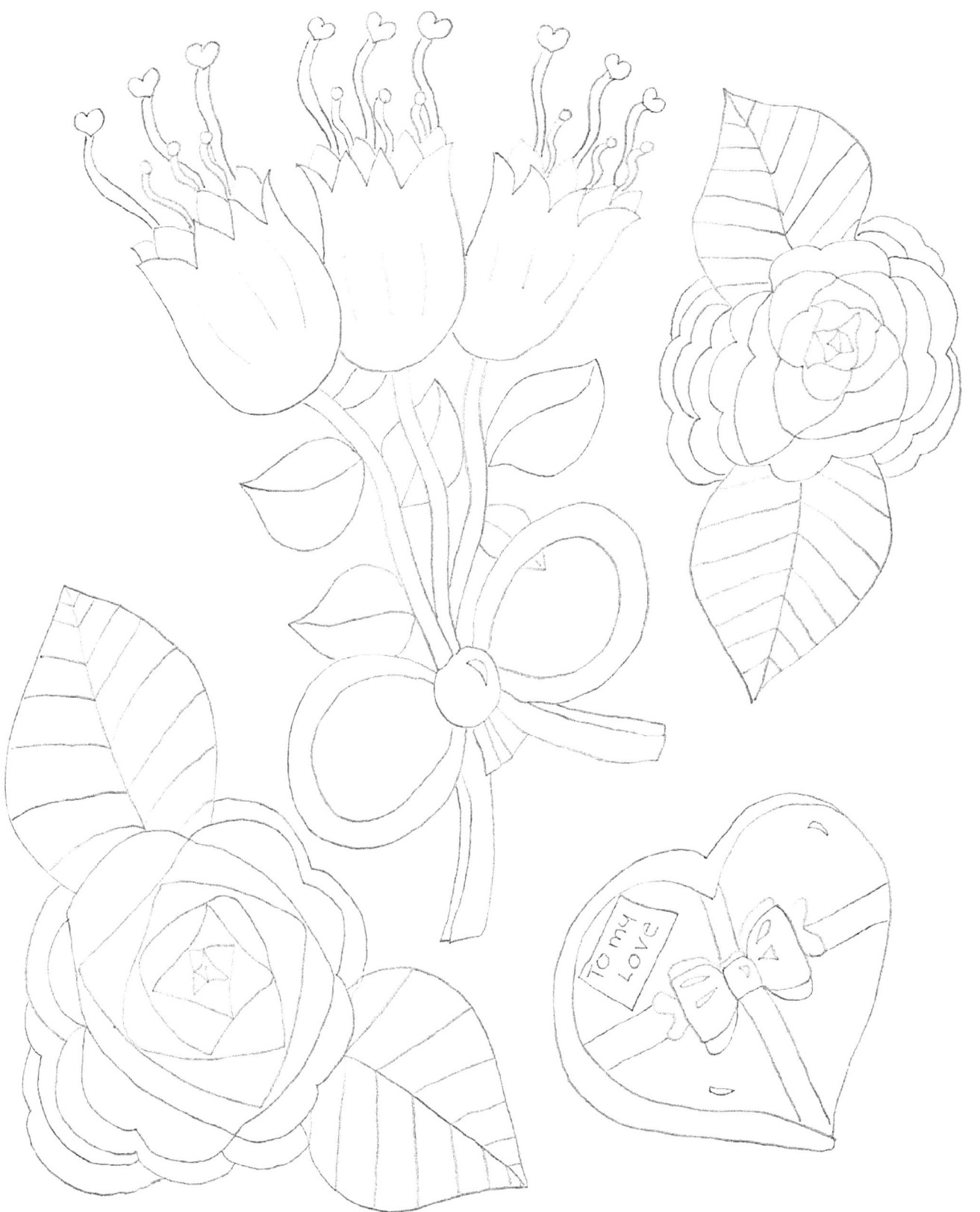

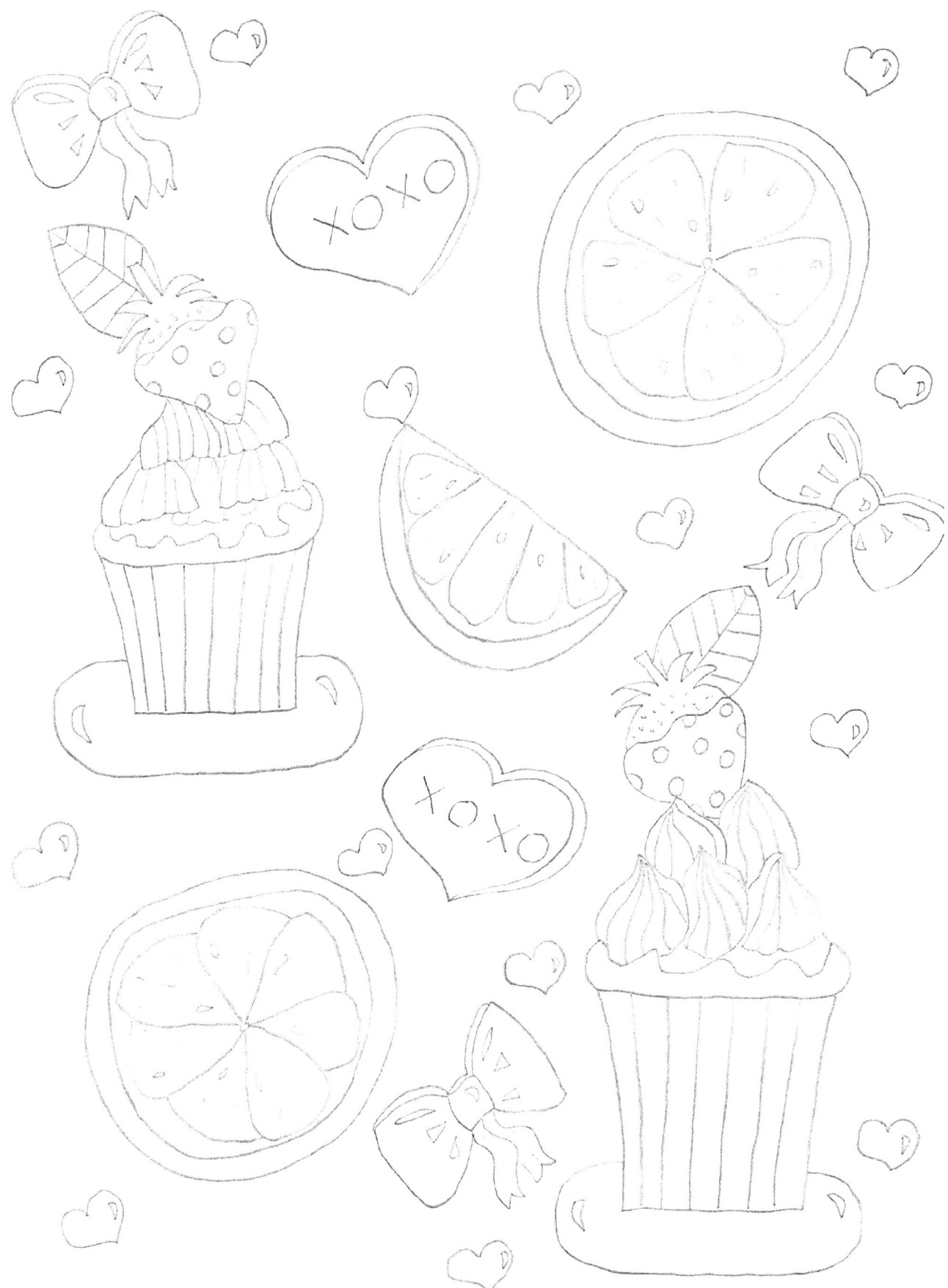

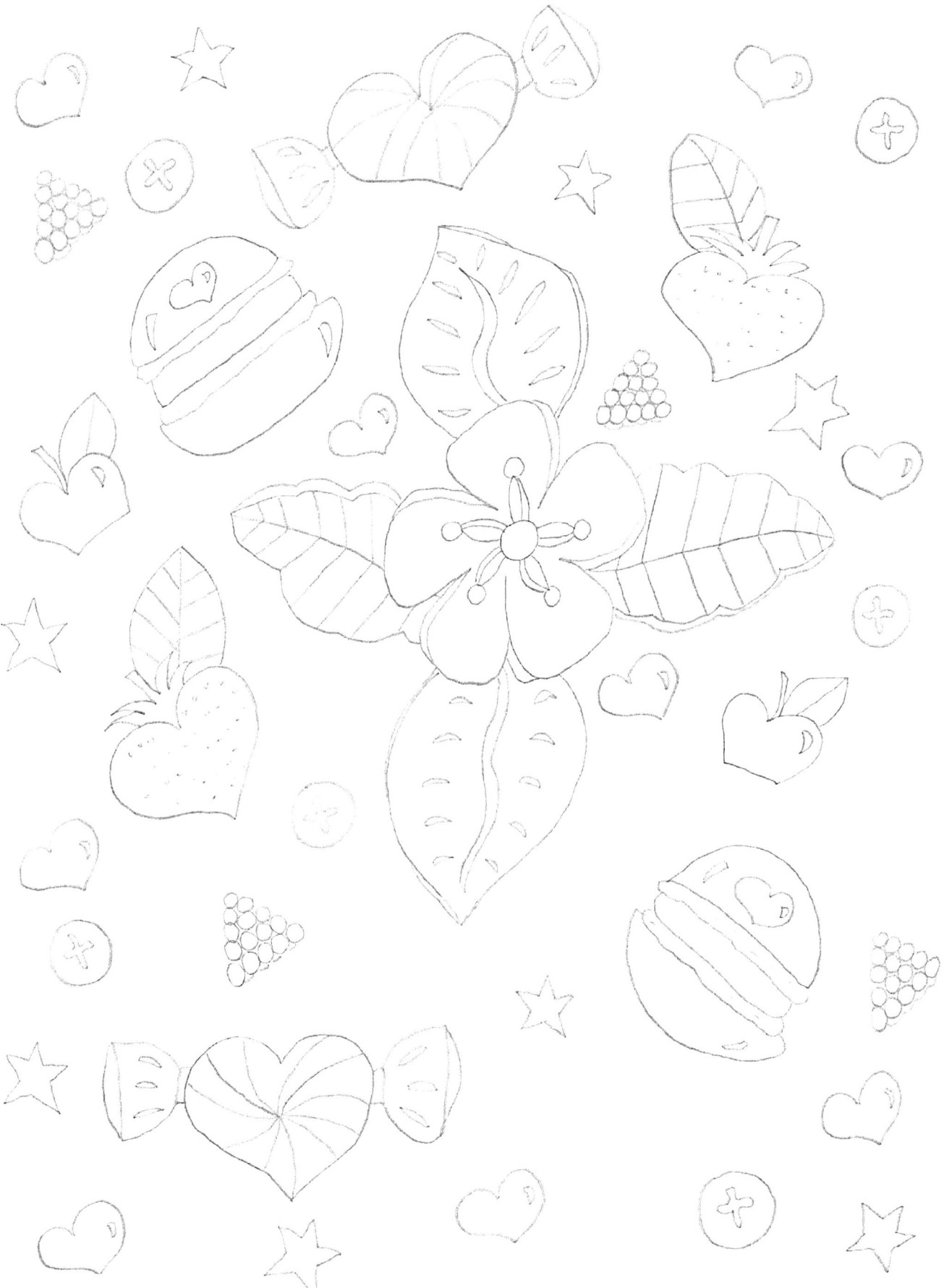

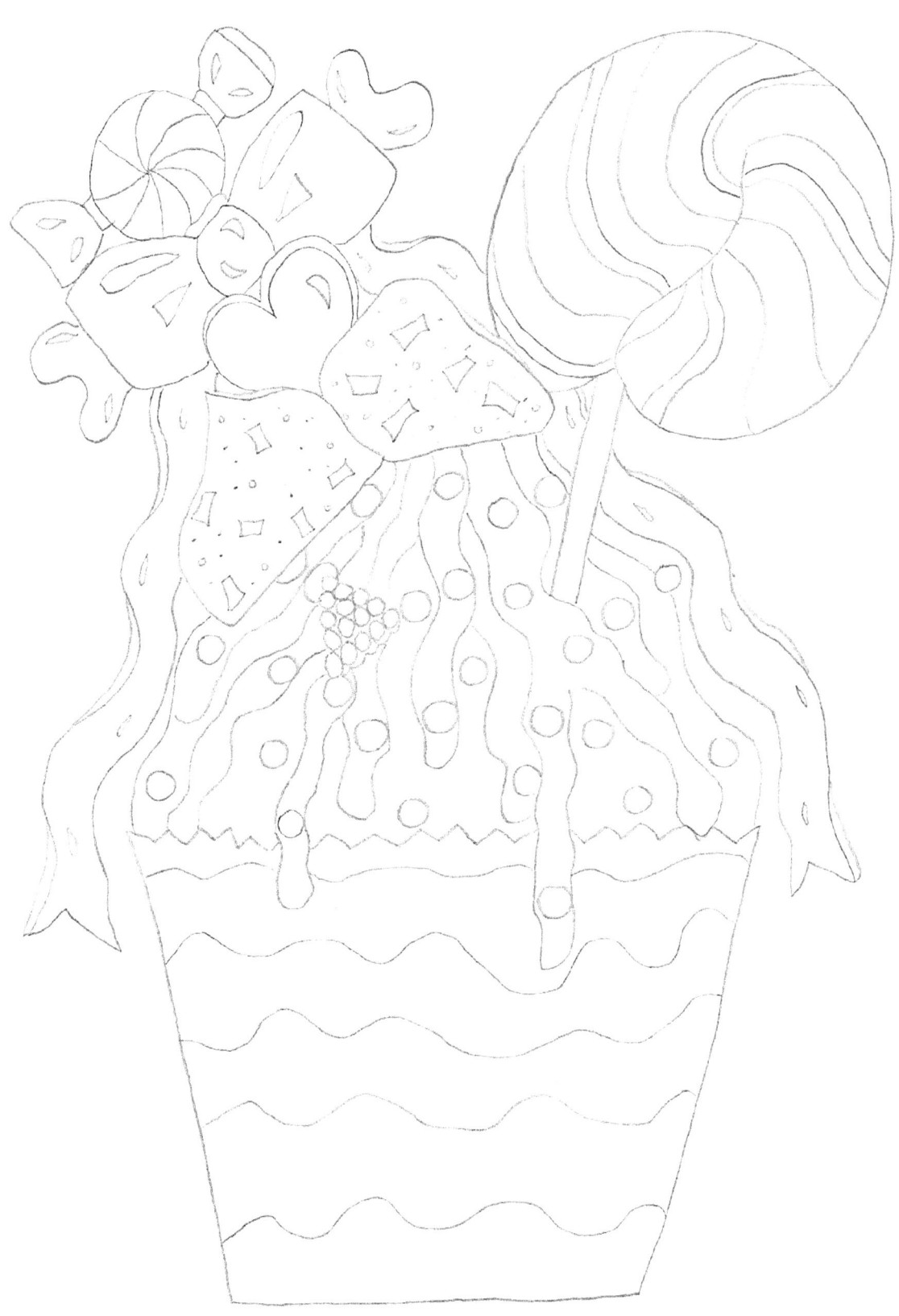

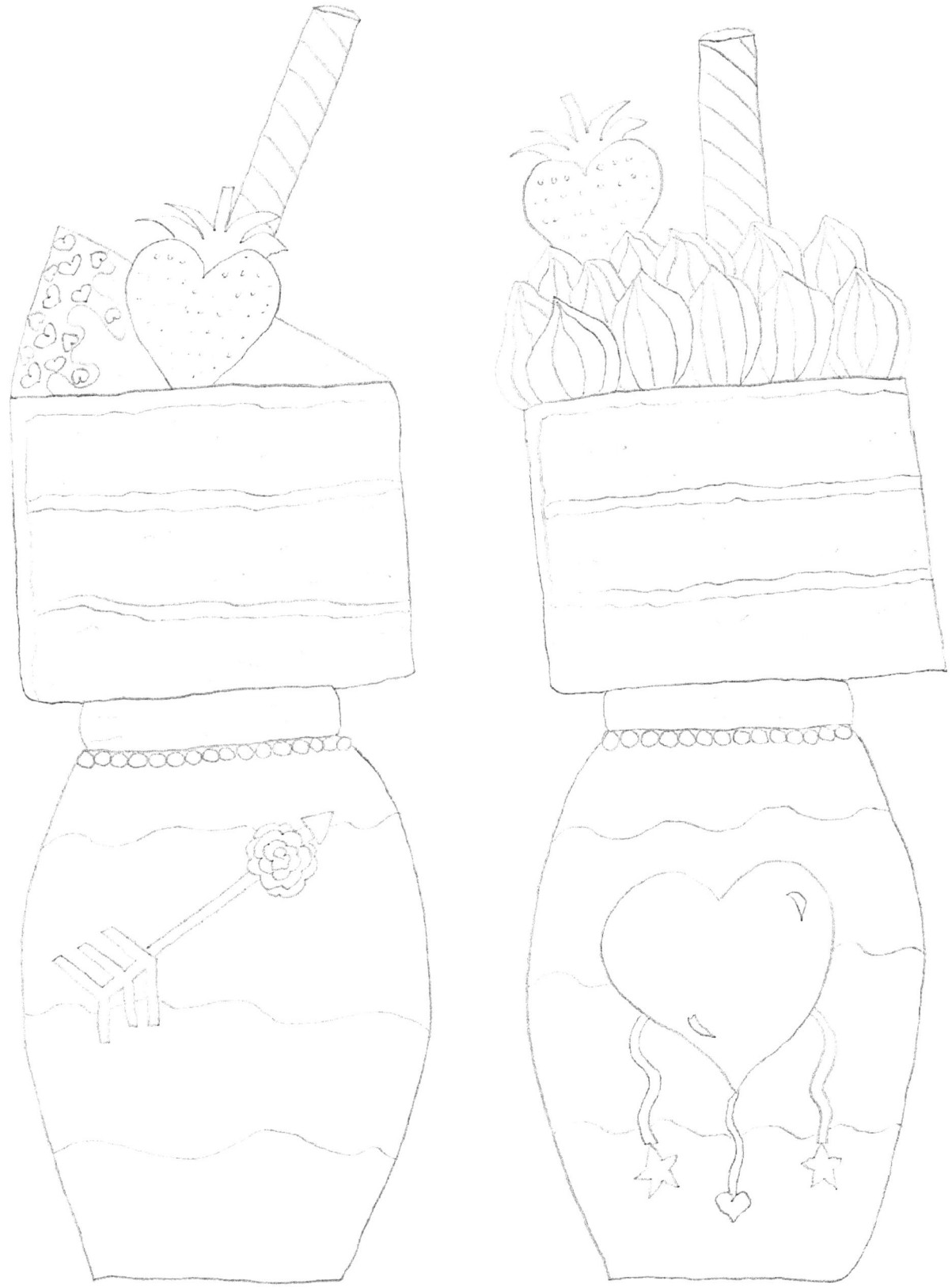

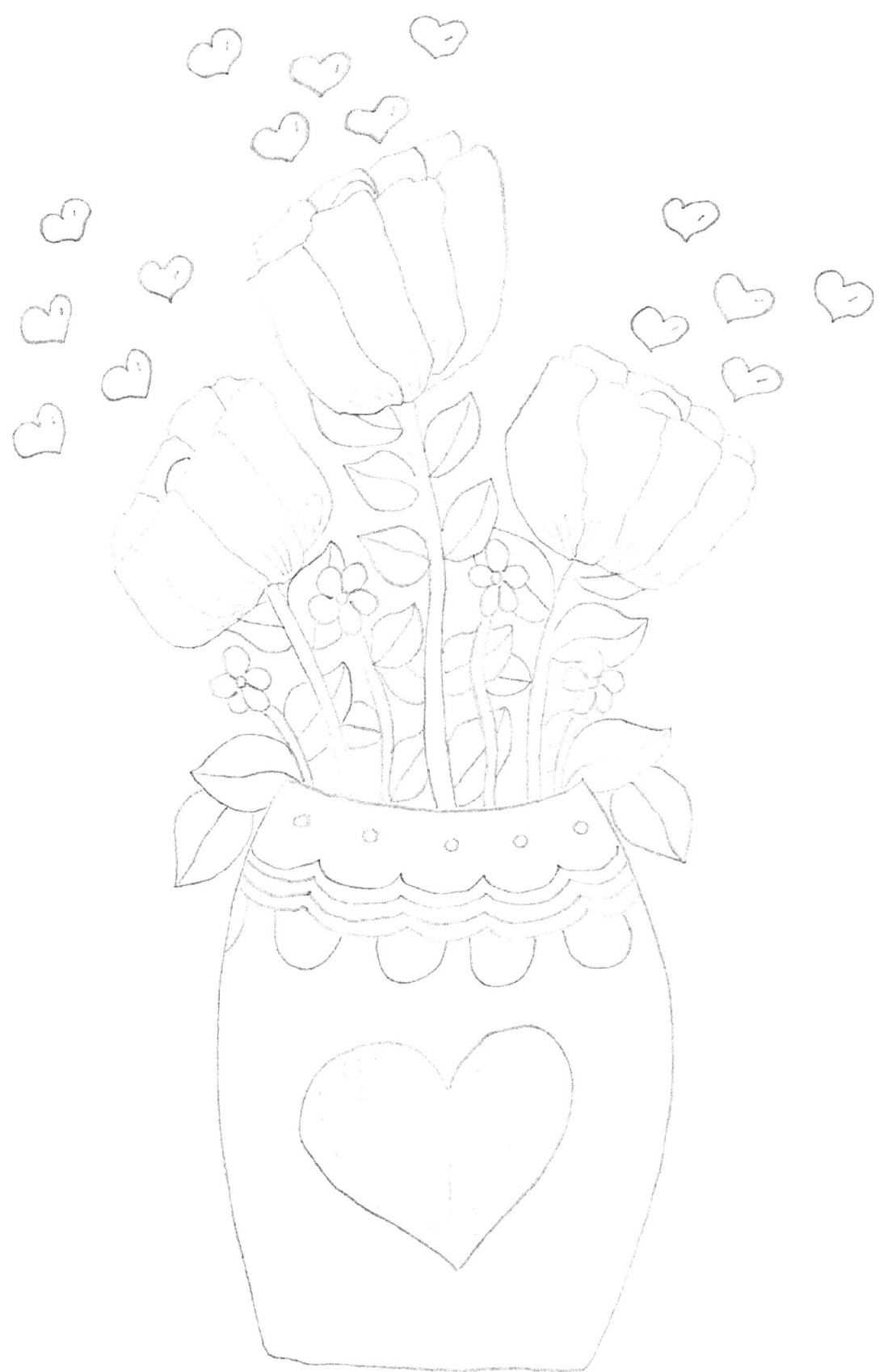

Thank you for purchasing A Very Rustic Valentine's Day. You can check out my other coloring books listed below which can be purchased at Amazon.com:

VINTAGE PARIS BAKE SHOP (Adult)

VINTAGE WINE GARDEN (Adult)

ICE CREAM MADNESS (Adult)

ICE CREAM MADNESS VOLUME 2 (Adult)

TEA & COFFEE TROPICAL TREASURES (Adult)

TEA & COFFEE OCEAN TREASURES (Adult)

TEA & COFFEE TREASURES (Adult)

BOTANICAL FLOWERS & MANDALAS (Adult)

MAJESTIC FALL (Adult)

A VERY RETRO CHRISTMAS (Adult)

MAGICAL DESSERTS (Children)

MAGICAL DESSERTS VOLUME 2 (Children)

MAGICAL DESSERTS VOLUME 3 (Children

FASHION DOLLS (Adult)

FAIRIES IN THE FLOWER GARDEN (Adult)

MERMAID'S WONDERLAND SEA OF ENCHANTMENT (Adult)

CHRISTMAS DESSERTS

VALENTINE'S DAYDREAMS COLORING BOOK (Adult)

VALENTINE'S DAY DELIGHTS (Adult)

VALENTINE'S FLOWERS & DESSERTS (Adult)

VALENTINE'S DAY DESSERTS (Adult)

VALENTINE'S DAY ANIMALS & Sweets (Children)

VALENTINE DAY'S FLOWERS (Adult)

IF YOU ENJOYED YOUR COLORING EXPERIENCE, PLEASE TELL OTHERS ABOUT IT BY WRITING A REVIEW ON AMAZON.COM UNDER THE BOOK YOU COLORED.

www.ingramcontent.com/pod-product-compliance
Lightning Source LLC
Chambersburg PA
CBHW081639220526
45468CB00009B/2494